Composing a Natural Science Illustration

From inspiration to Framing
a concise overview

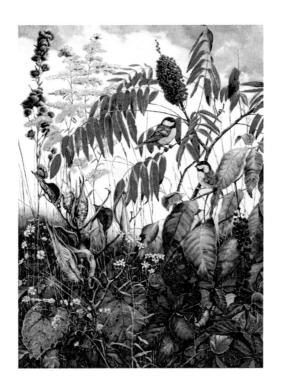

Written and Illustrated
by
Sandy Williams

www.soundofwings.com

Constructing a
Natural Science
Illustration

Index

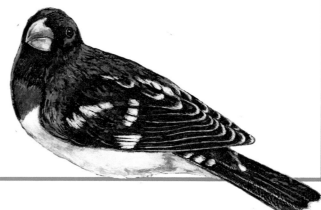

Introduction

Illustrating natural science subjects is one of the most rewarding branches of art. Creating detailed records of the plants, animals, birds and bugs around us in an accurate and appealing way can be difficult and time consuming. I hope this workbook can help you to make a plan that will simplify the process.

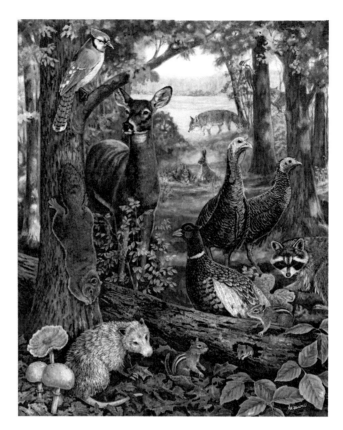

"Forest's Edge" -- gouache, 17" x 21"

Many natural science illustrations show a single specimen in all its glory. This workbook addresses another type of illustration -- one that incorporates many different elements into one cohesive composition that generally includes a bit of landscape, however minimal. The main purpose of these illustrations is to convey information and the aesthetics are secondary. These are not "wildlife paintings" that are done with a different purpose in mind.

This workbook is divided into sections on inspiration, research, composition, drawing, painting (geared toward those who paint with gouache), an explanation of how I composed the cover painting, "Midwest Summer," framing and then a call to action for you to follow to create your own illustration and to help you keep your focus on your goal.

Good Painting!

1

Finding Inspiration

Life is happening around us at breakneck speed, changing so rapidly it makes my head spin. As natural science illustrators our focus is to show particular aspects of this panorama. We need to find the things that have meaning to us, that are worth the time and effort it takes for us to create accurate images that convey information to the viewer and will also delight her/his eye.

In one way or another every bird, bug, animal or plant can lead to inspiration. What is it that interests you? What is it that captures your imagination? Everything? Hmmm. Well, you'll have to narrow it down a bit. Unless you have a particular assignment or commission you'll need to choose your subject and decide how you'll present it. For some people this comes easily. Sometimes an idea will come easily for me, but other times I find myself staring at a blank sheet of paper, unable to find that spark that will ignite my creativity. If chocolate therapy doesn't work, there are some other things I can try.

* Go through a stack of my old reference photos

* Drive to the local grocery store to check out the produce or to a nursery to check out the plants to see if I can find an interesting botanical subject

* Walk, walk, walk

* Sometimes I can find inspiration by sitting quietly, doodling in my sketchbook, with the dog or cat curled up beside me.

* But my #1 method is to make lists. I love lists! Since I like to paint ecosystems I might pick one I've never painted before and try to list the animals, birds and plants that might live in it. I might make a list of all the birds that come to our feeders. Have I painted them all?

At the bottom of this page is a copy of a page from my sketchbook. I was working on a series of bird paintings for the decorative market and I'd already completed a Crow and Hummingbird. What next? First I listed some more common birds on the left. Then I listed other elements that could be included in my illustration in the center and on the right side of the page. I decided on a Robin with Apple Blossoms, changed my mind, crossed out Apple Blossoms, and decided on nice, ripe strawberries instead. From there I made a rough thumbnail (shown on the next page). Can you tell that the bird and the strawberris were basically unchanged when I finally drew the finished piece? I added the old wooden bucket to add a human element. There was supposed to be a butterfly on the rim of the bucket but my deadline was looming. I hope to get back to it in the future.

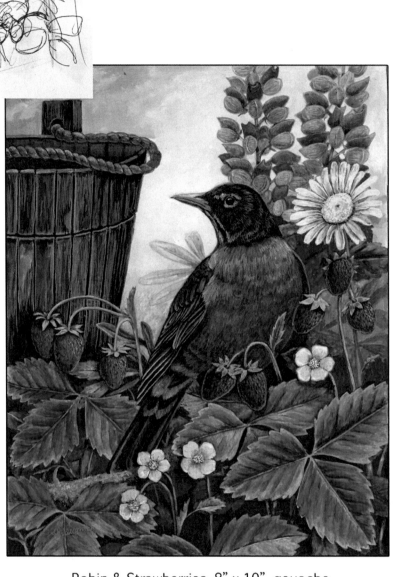

Robin & Strawberries, 8" x 10", gouache

I hope these tips on finding inspiration will help you. In the end,
your path to creativity is your own and it can often be a winding one.

Research

Research is one of your most powerful tools. Choosing your subject is just the beginning of the creative process. If you're illustrating a botanical specimen and you have the living plant in front of you -- great. You don't have to be a trained botanist to paint complete, accurate representations. But take your time to really "see" the plant. Look at it very carefully. And do some research about your specimen to make sure you haven't overlooked something. The best case scenario is to have the actual specimen in front of you. But what if your subject is a songbird? Even if you're looking at the bird through your window as it visits your feeder it's almost imposssible to make a detailed drawing or painting because it's always in motion. What if you've chosen a lion or tiger or bear? You probably don't have one outside your back door. It's illegal and unethical to copy other people's photographs. You may be able to visit zoos and wildlife centers to take your own photos. Maybe not. The key is research.

When I start a new painting I make preliminary sketches, from 6" x 8" to 2" x 3" in size. They're very rough but I try to envision the animal or bird in the pose I want it to be in. I try to get the sizes correct if there are several animals or birds together or at different distances. I rough out a background.

Then the research comes in. How lucky are we today to have the internet?! I try to find as many photos of my subject in a similar pose as I sketched it in as I can. In all the paintings I've done I've seldom found one that's exactly the same as my sketch. And I don't want to -- that would be copying and plagiarism. It's then my job, as an illustrator, to interpret the informtaion and transform my sketch into a finished drawing or painting using the information I've gathered from other sources. I'll use the hair pattern on the body of an animal from one source, the details of a paw from another. It's like putting the pieces of a puzzle together. Another option would be to contact the photographer of an image you'd like to use, ask them for permission and you may pay a fee for the privilege.

5

Don't let the lack of a live subject at hand inhibit your creativity. You have many resources at your fingertips: zoos, nature centers, botanical centers, grocery stores (produce section), your local library, online sites or even books on your own shelves or subjects in your own backyard.

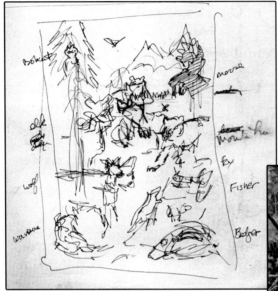

Prelimary thumbnail for "North Woods"

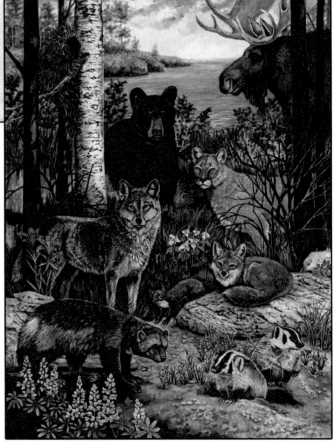

Finished gouache painting
"North Woods"
17" x 21"

Composition
The Golden ~~Rules~~ Guidelines

There are rules for composition. Lots of them. I'll go over some of them here but there's a reason why I've crossed out the word "rules" and replaced it with "guidelines." Don't make the rules your master. Be aware of them and know that they've been used by great artists for centuries to create amazing drawings and paintings. But don't let them intimidate you. Deviation from a rule doesn't mean that your piece is inferior.

The Rule of Thirds -- This is used to determine the focal point in your painting. Divide your surface into equal thirds, both vertically and horizontally.

horizontal composition

vertical composition

like thisorlike this

Your focal point should be positioned at any of the intersections of the lines, or 1/3 up or down (like a horizon line) or 1/3 across (like a tree). What you want to avoid is having your focal point be directly in the middle. Don't make a horizon line that splits your composition into two equal parts. The same would apply to a tree.

Tangents -- A tangent occurs when two of your elements barely touch each other. This can look very awkward. An example would be if the top of the head of one of your animals barely touched the horizon line or a branch. A better way to handle this situation would be to have the elements slightly overlap or to move them further apart.

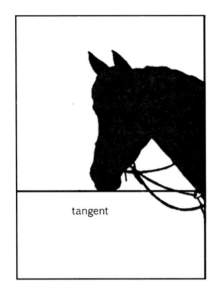

The horse's nose is touching the horizon line -- not good!

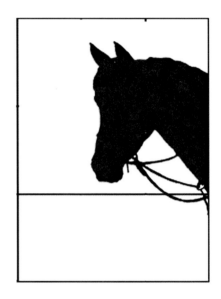

Here the horse's head has been raised up away from the horizon line -- much better!!

Placement of Elements -- Since this workbook is about natural science illustration, look around your landscape to see how all the elements are placed. If things are too even or perfect your composition won't look natural. The variety in the placement of the trees, plants and open spaces is pleasing and interesting to the eye. If you're doing a close up of butterflies, for example, pay attention to how you space them apart. Spacing them equally will make a boring composition. Group some together and make others farther apart.

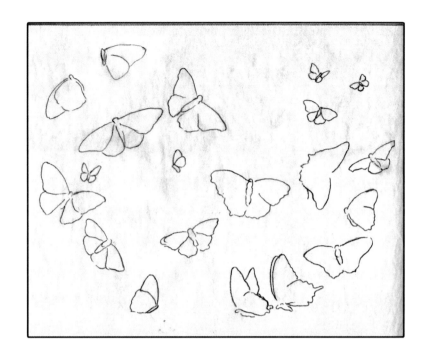

Illustration
A

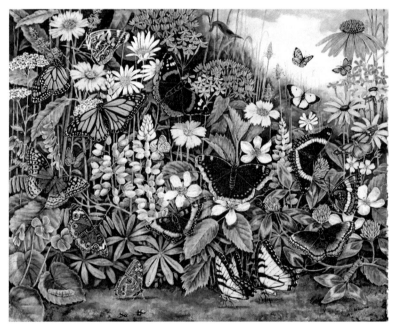

Illustration
B

"Butterfly Summer"
gouache
17" x 21"

 Illustration A shows a map of the preliminary drawing of the painting, "Butterfly Summer," where I've placed all the butterflies. The finished painting, Illustration B, shows how I placed the flowers around them. I really did draw in the butterflies first because they were the main focus of my painting. The flowers support the main elements and I manipulated them to showcase the butterflies.

A problem I run across frequently when I have many elements in the same painting, as in "Butterfly Summer," is sizing. I'm not always sure that my first drawing is the correct size in comparison to the other elements. A trick I've learned is to use a copy machine to make several copies of my image, in this case a butterfly, in several different sizes. I cut them out and then use white artist's tape to temporarily tape them right on my paper. Then I can step back and choose the right one to transfer to my final paper.

When you do your layout, be aware of how you place the secondary elements near your main focus. Make sure you don't make awkward juxtapositions, as in the illustration below.

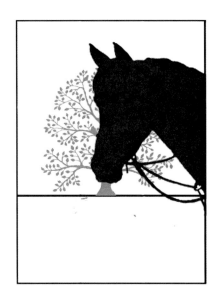

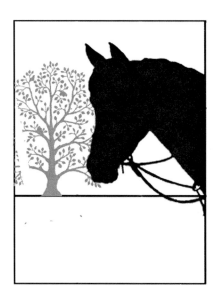

Here it looks like the distant tree is growing into the horse's mouth. Whoops!

Moving the tree to the left makes the composition read more clearly.

Balance -- Getting a good balance in your composition is very subjective and can be complex because so many different factors that must be considered. Size and number of elements; color intensity and temperature; placement of elements -- all figure in to balancing the composition. And what might be a "balanced" composition to one person might be a "boring" one to another. Think about what you're trying to convey to your viewer. How you balance your composition will say a lot about your intentions. If your composition is equally balanced (symetric) it will be more serene and controlled. If your composition is concentrated on one side or the other (asymetric) it can show more movement. Neither is right or wrong in itself. One or the other, however, may be a more effective way to get your message across.

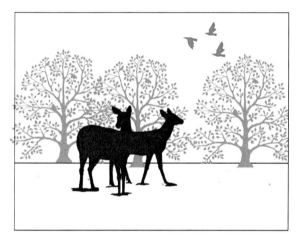

Symmetric Balance

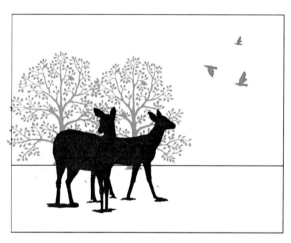

Asymmetric Balance

Values -- Value is the lightness or darkness of your element. Each element of your illustration should have a full range of values from dark to light. If something is one value overall it will lose its impact or spark. There can be one major value but be sure to punctuate it with darks and lights to break it up. Also, when you choose a main value for one element you have to take into consideration the values of the surrounding elements so that it will read well.

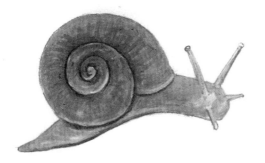 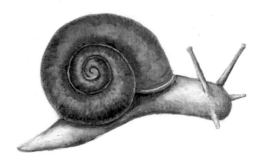

The value range on this snail is limited and stays mostly in the medium value range.

This snail has a full range of values, from dark to light and it looks more three dimensional and sharp.

When you place your subjects in their landscapes PLAN AHEAD. Make sure they will show up and be readable to the viewer. If you put a dark value subject on a dark background it will be difficult to see unless you make adjustments. You may have to subtly outline your dark subject to make it stand out. Or, if you plan ahead, you may be able to control your background values so that they are light behind your dark major elements and dark behind your light ones.

Look at the bluebird painting. The front of the bird is dark against the light sky but its tail and wings are light against the dark wood. This wasn't an accident. Plan Ahead!

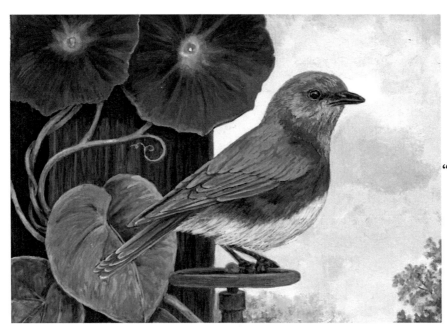

"Bluebird & Rusty Faucet" detail gouache 8" x 10"

Drawing

Good drawing skills are a product of practice. Draw as often as you can to develop your eye to hand coordination. It doesn't matter if you use a high quality pen or pencil on paper or a branch to scrape in the dirt. In our busy lives it's not always possible to draw everyday but try to make it a goal, even if your drawing is just a doodle of your coffee mug. Use what's available to you at the time.

One of the best recommendations I can give you is to start a journal and carry it with you. Sketch what you see around you -- notice the little details and also see the big picture. Develop your sense of observaion. The sketches in your journal don't necessarily have to be finished works. You may want to quickly record the attitude of a bird or animal or get a general sense of a pose. Practice, practice, practice.

When you've chosen a subject for your illustration and have either your specimen or reference material in front of you it's time to begin your final drawing. Sometimes I draw directly on the paper I'll be painting on. Sometimes I draw on another piece of light weight paper or tracing paper and then transfer the drawing to my good paper when I've finished it. Experiment and see what works best for you. When drawing as a prelude to making a painting, I don't do much detail. I'll be painting over it and that would be a waste of time. Keep it a simple line drawing.

Drawing Plants

The advantage to drawing a flower is that it sits still -- to a point. It's still a living organism and it does move -- nodding toward the light, growing, dying. So it's best if you can finish your drawing in one sitting. If you leave it partially done and come back to finish it the next day you may be in for a surprise.

13

Set up your specimen so that you're seeing it at the correct angle for your illustration. If you'll be doing a side view you may want to raise your specimen up a little. I put books under my vase or pot in this case.

Observe carefully. I usually draw a light line for the stem or stems first and make marks along it where the leaves are positioned. Be precise. Lightly indicate the flower head (florescence). Don't worry about the details at first -- just make sure you have all the elements of the plant in the right proportions. To better show the steps I've demonstrated how I draw an Ox Eye Daisy.

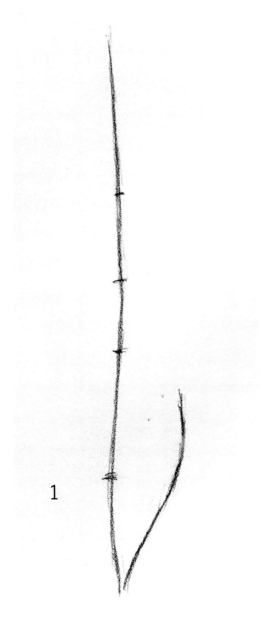

I've used a soft 4B graphite pencil so that it's more easily seen for this demo. You may want to use a harder pencil. You choose. Just remember that you'll need to erase some of your lines as you draw so, at first, make your lines light.

1.) First, I made light lines for the stem and a long lower leaf. Then I drew lines to mark where the leaves will be positioned along the stem.

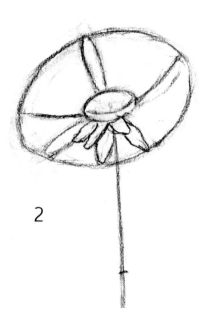

2

2.) The blossom -- First I penciled in the center of the flower. Be very careful to draw the ellipse correctly. The only time it should be drawn as a circle is if you're looking straight down at the flower. Next, I lightly indicated the outside oval where the ends of the petals will be. I also sketched in a few of the petals in different areas around the center to get a general idea of how they'll be placed as the drawing progresses.

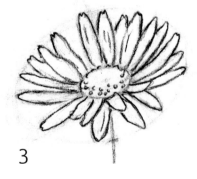

3

3. Next, I finished drawing the petals. Erase the outside guidelines and put a little detailing in the center.

4

4.) To finish my drawing
I drew in the rest of the
stem and added the leaves.

 Always take into consideration how you'll be finishing your illustration. If it will be done entirely in graphite you'll need to be very detailed with your drawing. But if your drawing is the basis for a gouache, acrylic or oil painting it doesn't pay to put the details in your drawing. They'll just get covered up. If at all possible make a copy of your drawing to refer back to as your painting progresses. Since this drawing is preliminary to a painting I'm not going to add much detail.

Drawing Birds & Animals

So, you've chosen your subject, done your research and explored your composition through the use of thumbnails. You know your bird or animal well and you know what pose you want to draw it in.

When drawing birds and animals think "volume." You don't want to just draw the outside edge of the outline. I've included two demonstrations here -- the first is a Rose Breasted Grosbeak who posed very prettily for me outside my window. The second is a chipmunk who was wandering around the zoo in Grand Rapids, Michigan.

Here I've used tracing paper to make my drawing. That will make it easier to transfer my drawing to my good paper when I'm ready.

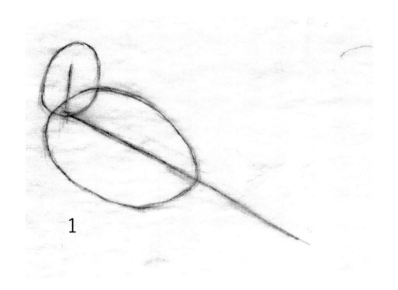

1

1.) Take a good look at the bird and try to see it as a series of ovals and lines. Draw the straight lines to capture the attitude of the pose and set the proportions. Add the ovals for the head and body.

17

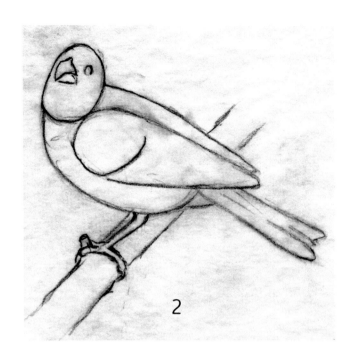

2.) Keep thinking of the bird as simple shapes. Draw in the shoulder and wings. Add the beak and eye to the head. Also, draw in the tail, leg and simple branch. Remember to keep your lines drawn in lightly so they'll be easy to erase. At this point you can erase your original guidelines.

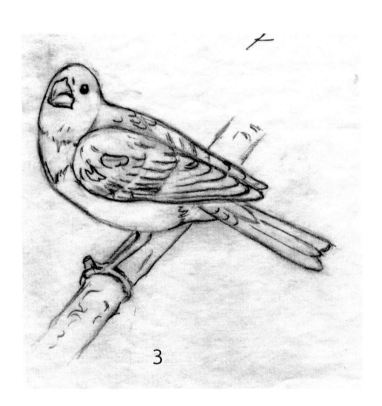

3. Now refine your drawing. Sharpen your pencil so it will be easier to make the lines. Denote the feather patterns on the wings and tail and draw in the chest patch.

Remember that your drawings are the basis for a painting and you will be wasting your time if you put in too many details. Try to make a copy of your drawing so you'll have it to refer back to when you begin painting.

My reference photo of this chipmunk was not exactly how I wanted to show the little animal. I looked at another photograph I took the same day and used the ear from that one. Neither photo showed the tail so I got on line and found one there.

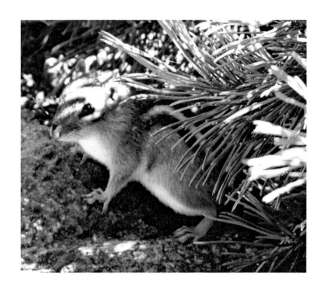

Again, I've used tracing paper to make my drawing. That will make it easier to transfer my drawing to my good paper when I'm ready.

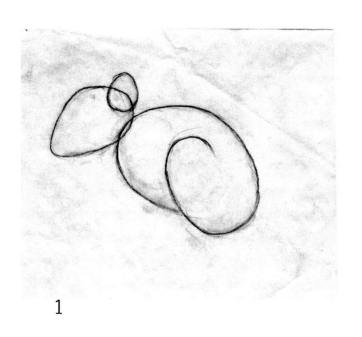

1

1.) Simplify the form of the chipmunk. Think of the chipmunk as being made of a series of ovals at first. Try to get them in the right proportion to each other.

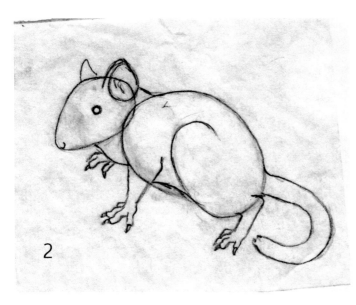

2.) Place the eye in the right position on the head. Connect the head to the body and add the legs. Legs and feet are some of the most difficult things to draw on an animal so take your time. Also draw in the tail.

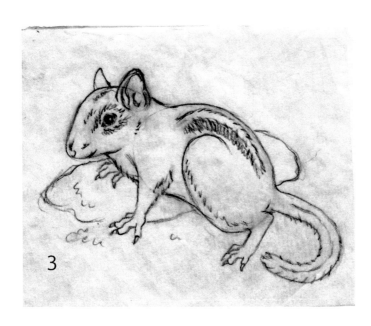

3.) Erase your unnecessary guidelines. Put the detailing in on the head and put in the hair pattern lines on the body and tail. Remember -- this isn't a "finished" drawing. This is the preliminary drawing for a painting. Don't put in too many details.

Painting

There are way too many different media that can be used to paint your illustrations than what I can cover in this workbook: oil, acrylic, markers, ink, pastel, colored pencil, transparent watercolor, mixed media . . . and gouache. Since gouache is my specialty I'll be gearing this chapter towards those who also use it. If your favored medium is something else please check out your local library or online sources to get more information. One thing I want to stress to everyone, no matter what medium they choose, is to practice, practice, practice!

Gouache, pronounced "gwash," is an opaque watercolor. It's convenient to use and economical after an initial investment because there is little waste. When the paint dries it can be reconstituted by just adding water. Besides being a wonderful medium to depict colors, subtle or bright, and the tiniest of details, it's very forgiving which is important to me because I change my mind as I go along and make some changes.

Materials

This is a basic list of materials for painting with gouache:

Brushes -- 3 small rounds, #1, #4/0 and #20/0 -- think tiny
Palette -- white, one that has a lid that closes is nice
Small Water Container
Watercolor Paper -- Hot Press is best for detailed work,
 I use Arches #140 hot press, but illustration board,
 vellum or bristol also work beautifully
Gouache -- I use the kind that comes in tubes, mostly Winsor
 & Newton brand. The following are the most used colors
 in my palette
 Permanent White, Burnt Umber, Ultramarine Blue,
 Burnt Sienna, Brilliant Yellow, Primary Blue, Spectrum
 Red or Primary Red, Bengal Rose or Opera Rose,
 Brilliant Violet, Olive Green, Marigold Yellow, Yellow Ochre

There are two basic techniques that are all important when you're painting realistic natural science illustrations with gouache: layering and blending. Also, always remember to soften the outside edges of your subjects so they don't look like they're pasted on the page.

Layering -- Generally, with gouache, I work light over dark. This means I first paint a thin layer of a dark value over my subject and build my lighter layers over that. An exception is when I'm using red, as in a cardinal, because the darker layer might dull the brightness of the red. But, usually, I paint the thin, dark layer first. Make sure this first layer is thin enough so that your drawing shows through. Each subsequent layer is a bit lighter and thicker and you never want to completely cover the layers underneath so they show through and give a 3D effect.

Below is an excerpt from my workbook, "Painting Animals in Gouache," using painting long, soft fur to show the different layers.

Long, Soft Fur

(1) (2) (3)

| Using a dark mixture of Burnt Umber and Ultramarine Blue, roughly paint in some long, flowing hairs. | Using a middle value of a mixture of the same, colors added to white , paint another layer of hairs. | Using pure white paint the top layer of hair. Don't completely cover up the lower layers. Some of the dark should show through. |

(4) Gently move your damp brush along the hairs to soften the lines. The brown underneath will mix with the white and turn it a light brown. If you lose too much of the white, just add more. Then gently blend again..

The last step also shows the importance of blending.

Softening the Outside Edges -- You want to keep away from hard outside edges because they can separate your subject from the rest of the painting and make it look pasted on. Take a slightly damp brush and gently run it across the edges to blend them in a little and "join" the image to the background. Don't use too much water in your brush or it will entirely wash away part of your work.

Blending --Gouache was one of the mediums used in the golden age of commercial illustration and it developed a bad reputation in fine art circles because it was only being used for large, flat areas of bright color. It was thought of as being more of a decorative medium. Currently, gouache is enjoying a resurgence in popularity with fine artists and illustrators because its been found that very realistic results can be achieved, partly through the use of blending.

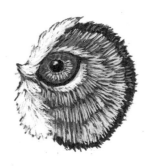

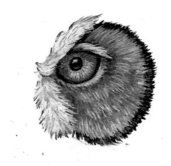

The Great Horned Owl's eye has been layered but not blended. The lines are prominent and harsh.

This Great Horned Owl's eye has been both layered and blended. It looks much more realistic.

Blending is done with a slightly damp brush. If you have too much water on your brush and touch it to your painting it could very easily wash away your strokes completely. I always have a paper towel in the hand that's not holding the brush and I swab off the brush before I begin blending. Very gently, run the tip of your brush along the stroke you want to blend, just enough to take the hard edge off. If you're blending hairs, you'll want to do heavier blending on the part of the hair near the animal's body and leave the tip of the hair sharper. Yes, this can be time consuming but the results are worth it. If you find you've blended too much and your stroke has disappeared, just paint in more of your light or dark and reblend. Gouache is very forgiving and can be reworked many times.

Tips on painting your background: These are true no matter what medium you use. It's generally wise to paint your background elements first. There's no sense painting a beautiful animal with shaggy fur and then trying to paint in the background behind it. You would have to repaint all the tips of the hair that touch the background area.

If you're including a landscape or part of a landscape in your composition there are a few things to keep in mind. I've used the simplified landscape pictured below to help illustrate them.

The composition is made up of three different planes -- the background, the middle ground and the foreground.

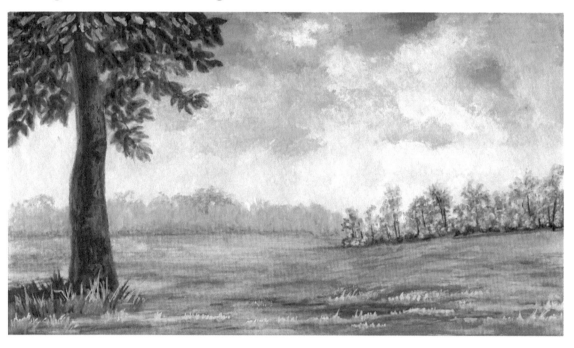

The background: The sky is always lighter near the horizon line. The objects near the horizon line, in this case the distant trees, have a blue cast and show little detail. This is called aerial perspective.

The middle ground: The line of trees on the right has more detail and the color is closer to the local color of the trees.

The foreground: This is where the details are most prevalent, along with a full range of values, from light to dark, as in the large tree on the left.

A landscape can convey a sense of space and "place" for the main subject. Remember that it's a support and it should complement your main purpose.

Painting Skies -- We're all experts on what skies look like -- ever changing and beautiful, capable of setting the mood for our every day existence. They can also set the mood for the painting they appear in. Because most of the skies in my paintings are very small parts of my composition I keep them subtle and simple -- a pale blue with some white clouds. They're great backdrops to show off my main subjects. But we all know that there's so much more to them.

The following is an exercise to show the variety of colors that you can add to your skies to develop a particular mood. Don't be too careful with this project. Explore the possibilities.

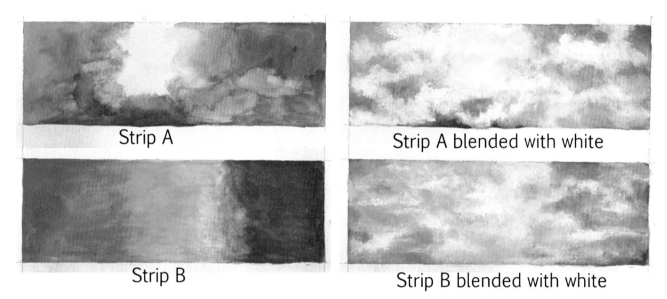

Strip A Strip A blended with white

Strip B Strip B blended with white

Here I've measured off two rectangles, 9" x 3" each. On the two strips on the left I've haphazardly added thin layers of gouache in different colors. To these same two strips I've added thick white gouache (like clouds) and blended it in as shown on the right side. Use just a touch of water to do the blending. Watch as the colors underneath mix with the white and create subtle variations. Study the different effects of the colors. The brown has the look of a sky before a storm. The yellow gives me the sense of the sun peeking through. The pink reminds me of an early dawn.

To paint a sky I don't usually use color straight from the tube. By overlaying the color with white and blending a little you can get a certain amount of depth and luminosity. Remember -- don't use too much water! This is almost a dry brush effect. You want some of the color from underneath to show through, not just mix with the upper layer of white.

Textures -- Rough bark, gnarly branches, soft petals, speckled rocks and other textured elements are often encountered in natural science illustration. Following are two demonstrations -- one on painting a rock and the other on painting a branch. The general guidelines of painting with gouache apply here -- dark underpainting, layering, blending and softening the outside edges.

The Rock Colors used: Burnt Umber, Ultramarine Blue, Permanent White

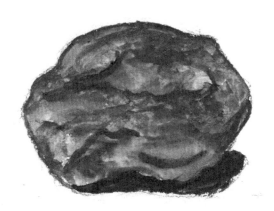

1.) Use a thick, dark mixture of Burnt Umber and Ultramarine Blue to paint the outlines and main interior lines of your rock and shadow. Use a thin wash of the same mixture to cover the rest of the rock, being sure to let your lines show through. You don't have to be too careful at this point.

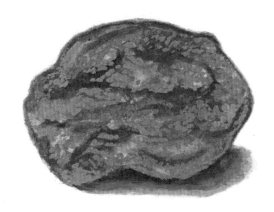

2.) With a medium value gray made by mixing Burnt Umber, Ultramarine Blue and Permanent White, paint a series of dots over your dark value, letting some of the dark value show through. Don't cover up the dark lines you've already painted for striations in the rock. With a ' damp brush soften the outside edges.

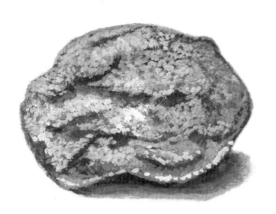

3.) With thick, pure Permanent White, use the tip of your brush to dab little bits of texture on the rock. Be sure some of the lower layers show through.

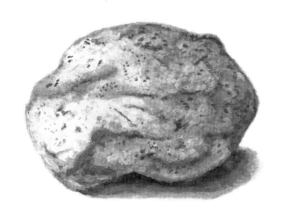

4.) With a very slightly damp brush, blend the White in a little. If you blend too much just add more of the value that you washed away. When you're done with that step, add tiny little dots and lines using your darkest mixture of Burnt Umber and Ultramarine Blue. Gently blend the hard edges away.

The Branch -- Colors used: Burnt Umber, Ultramarine Blue, Yellow Ochre
Primary Blue, Permanent White

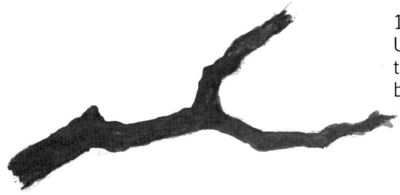

1) With a dark mixture of Burnt Umber and Ultramarine Blue, paint the underpainting over the whole branch.

2) With Yellow Ochre, paint a medium value on the upper surfaces of the branch. Make your strokes go with the curve of the branch's contour. With a slightly damp brush, very gently blend the Yellow Ochre in a little. Don't forget to soften the upper outside edges.

3) With pure White, paint on the top layer of the branch. At first the white will look too bright but gently blend it in and it will mix with the color below. You may have to add more white and reblend. Don't make your strokes too evenly spaced. Also, mix White with Primary Blue and paint in the line of reflected light along the bottom of the branch. Blend it in and don't forget to soften the outside lower edges.

Composing "Midwest Summer"

This chapter will walk you through how I worked out my painting, "Midwest Summer."

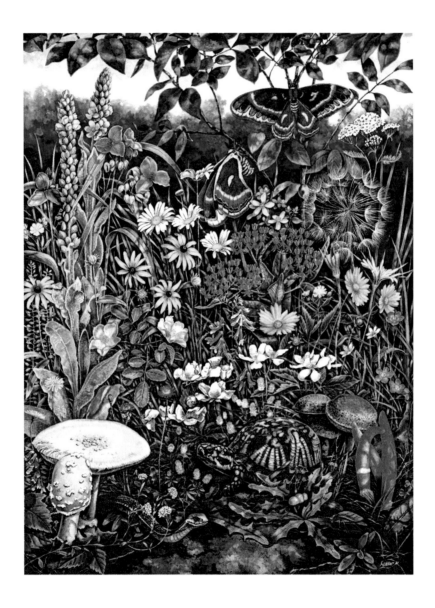

The year was 2000 and I'd decided to do a series of four paintings depicting the four seasons as my salute to the changing of the millenium. "Spring Woodland" was already completed and I'd used a full sheet of Arches watercolor paper, 22" x 30", and I wanted all four to be the same size to give the series a sense of continuity.

As my inspiration for the summer painting, all I had to do was walk out my back door and into the field behind my house. My grandparents purchased the property in 1924 and my father grew up there, plowing the field with their two horses. Over the years I purchased over 11 acres of it and it became my "office," a place I often use to find subjects for my paintings.

It was the end of May and I decided I wanted to use as my subjects all the things that could have existed in a little plot of the field in June. I looked around me and made a list of all the plants that would be blooming throughout the month. I needed something a bit taller to act as visual interest and a change from the myriad of flowers I was going to include so I chose a honeysuckle bush. Besides the plants I wanted to include I had some good photo references of a Box Turtle, a Garter Snake and a Cecropia Moth that I wanted to fit in. All the photos had personal meaning and memories for me.

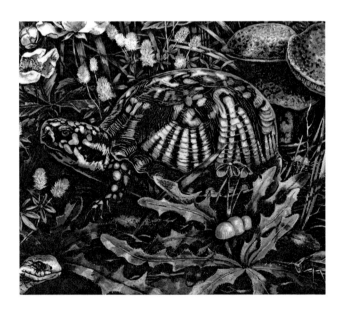

Ever since I was small we've had Eastern Box Turtles roaming our area. It wasn't until much later that I read that they can live to be 100 years old. After that, when I happened to run into one, I'd look at it and wonder if it saw my Dad plowing the fields there when he was a boy. Maybe. Photographing turtles is not as easy as it would seem. The box turtle would tend to pull its head and feet into its shell and it would be a waiting game, although not a bad way to spend a half hour or so.

Garter Snakes are one of the most prevalent types of snakes in southwest lower Michigan. One hot sumer day, a few years before I decided to do this painting, I cleaned out my little garden pond. I had completely bailed it out and the few frogs and one lone toad looked so forlorn as I hung the garden hose over the side of the pond to refill it. "It won't be long, guys," I said as I walked away to do some other chores. About a half hour later I came back and there was the snake, wrapped around the hose, staring with its beady little eyes at the frogs and toad. I remember thinking, fat chance. Those critters were also eyeing him and there would be no lunch for him that day. Wrong. I came back again another half hour later and the snake was in one of the plant pots in the bottom of the pond, the water level creeping up around him and a pair of toad legs hanging out of his mouth. Nature had taken its course. The weight of the toad going down his gullet slowed the snake down enough so that I had time to go back to the house and get my camera. And there he sits now, part of my summer painting.

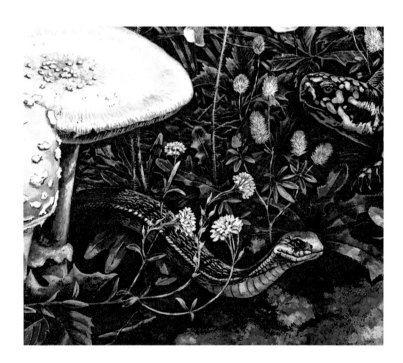

Snakes are one of the hardest things for me to paint and I'm not looking forward to painting one again.

I ran across the Cecropia Moth one afternoon as I was taking my Springer Spaniel, Ripley, for a walk. It was hanging on a bush with its wings folded tightly over its back. It was still there when I came back with my camera so I thought maybe it had just emerged from its cocoon and was drying off. I crouched down next to it, took photos of it as it was, and waited for it to open its wings -- and waited and waited. My legs were aching and Ripley was bored. He finally jumped on me and gave out a loud bark right in my ear. As I toppled over the moth, startled, opened its wings to reveal the beautiful patterns. Ripley has long since passsed away but I remember that day as if it were yesterday. And the velvet like Cecropia moth graces my summer painting, the same moth in two different poses.

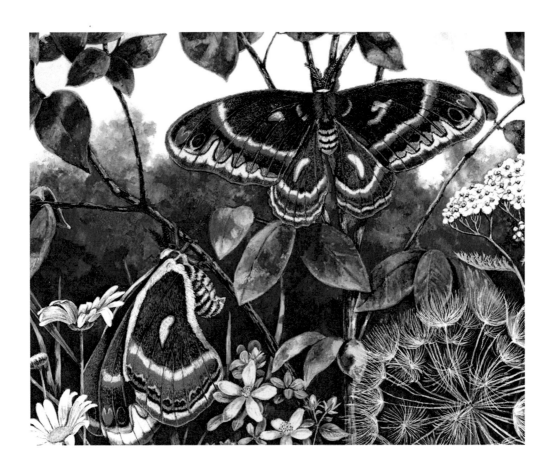

So -- look how much happened to construct this painting before I even touched a pencil to my piece of paper. This isn't just a painting -- it's a story. Actually, it's several stories intertwined. It has a personal meaning to me and I kept my inspiration at a high level -- luckily, because it took me three months to complete.

I had a general idea of where I wanted to place some of the plants that I had on my list so I was ready for them when they started to bloom. But most of the flowers were placed as I went along and found a place where they would "fit." They were coming on so rapidly I ended up taking photos of them and I had to use them for reference for some finishing up. It wasn't the best scenario -- it's always better to have the live plant right in front of you. But, at least I started my drawing and painting with them present and then took the photos. Little by little the painting took shape. Those of you who are familiar with painting detailed illustrations with gouache know how slow the process can be. Each element was collected, drawn into place and then layered, detailed and blended with gouache.

Not every painting is as involved as this one. This was an exception.

Keep on the lookout for things that interest YOU and that might, sooner or later, be something you'd like to incorporate into a painting. I've been keeping a "morgue" file for over thirty years and it's full of magazine and newspaper clippings. I have them filed by subject matter for easy accessibility. When I need to find a detail for a subject it's right at my fingertips. I also have my photographs filed in separate files on my computer. Your photos don't have to be professional quality. I've taken some horrible photos that I keep because one might have a very clear view of squirrel toes or something else that might be important down the road.

The best thing, of course, is to have the specimen in front of you but it's not always possible.

Framing

The final presentation of your work is very important.

Size -- It always helps if you make your illustration a "standard" size. That's not a rule written in stone, but it makes things go more smoothly when it comes time to frame your work. Always follow your creative instincts first, but keep it in the back of your mind that standard sizes (read more easily framed) do exist. Following are some frequently used standard sizes:

5" x 7"	11" x 14"	18" x 24"
8" x 10"	12" x 16"	24" x 36"
9" x 12"	16" x 20"	30" x 40"

Below is a diagram of the separate pieces that go into framing a work. Don't be intimidated. It's not as hard and as involved as it looks!

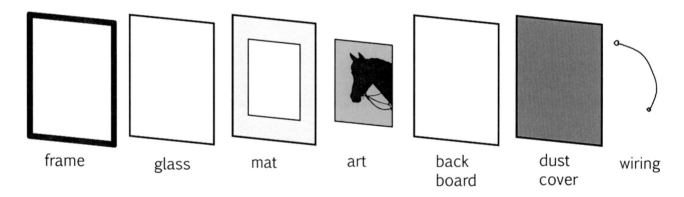

frame glass mat art back board dust cover wiring

Frames -- The frame has two purposes. It should protect the artwork and also help showcase it to its best advantage.
As with the mat, choose a frame that pleases you -- one that you think looks "right" for a particular painting. When you have your work in the frame the back will need to be covered by a dust cover for further protection. This is generally a piece of brown paper that's glued to the back edges of the frame.

Oil and Acrylic paintings -- If you're using either of these two mediums on stretched canvas you can get away with not using a frame at all. Just be sure to paint the edges of the canvas and, after wiring, it will be ready to hang. You also do not need mats or glass with these mediums.

34

Glass -- You have several options when it comes to choosing glass -- regular glass, conservation glass, museum glass or plexiglass. Regular glass is the least expensive and is very hard to scratch. Unfortunately, it's very heavy so if you'll be carrying it to different venues you may want to think twice. It also doesn't offer as much UV protection as conservation or museum glass. Although these two types of glass have better UV protection they can be very expensive and they're also very heavy. Plexiglass is lightweight and won't break so if you'll be carrying a large work this may be your best choice. If you'll be mailing your piece using plexiglass is often a requirement made by those who will be receiving the artwork for display.

Please note -- if your work is a pastel NEVER frame it using plexiglass. The static electricity that results can pull the pastel away from the substrate, leaving you with a pile of powder along the bottom edge of your mat.

Matting -- Matting serves two purposes -- it can help with the aesthetic presentation of your piece and it can protect it. Anything that could possibly be damaged by moisture or contact needs to be matted before framing. That includes gouache, watercolor, pastel and colored pencil. The main purpose of the mat is to hold the piece of art away from the glass where it could be smeared or absorb condensation. In some cases there are spacers that can take the place of the mat. The spacers run along the inside edge of the frame and can't be seen but serve the same purpose -- they hold your artwork away from the glass. Always use acid free materials for the mat, backing and tape or they will damage your work. Mat board comes in a wide range of colors and finishes and is readily available in most art supply stores. Choose a color that will complement your painting and not overwhelm it. Also, consider a double mat. This format has an inner mat that shows only about 1/8" to 1/4" directly around the painting, and the other mat is the main, larger one that shows on top. Smaller works generally look best with a 1" or a little larger mat while a larger work may look best with a 3" border all the way around your painting. Always go with what looks best to YOU. Your own judgement is the one that counts.

Backboard and Hinging -- The backboard should be acid free and the same size as your mat. It should be strong enough to support your art and acid free foam core board is often used for this purpose. Traditionally, art is attached to the backboard with Japanese paper and starch paste. These hinges are strong but not bulky and, if need be, can be removed with water. However, when I do my own framing on my smaller pieces I attach my art to the backboard with a strip of acid free removable white artist's tape. Always attach the art to the backboard, not the back of the mat board.

Hardware & Wiring -- No saw tooths! Ever! Screw eyes can be attached to both sides of the back of the frame. Specialty picture hanging wire is available that's rated for different weights and it can be run between the screw eyes. The screw eyes, however, prevent the painting from lying flat against the wall. Strap hangers, if available, work much better and allow the painting to lie flat without leaning forward at the top. To further protect your walls you may want to put little "bumpers" on the back corners of the frame. They're available at framing and art supply stores.

Call to Action

Just reading about how to compose a natural science illustration is not going to do you much good. Your skills need to be developed through practice -- your painting and drawing skills and your observational skills. In this workbook I've developed a plan that I'll be using in my five two hour session live classroom.

Session 1

Go over this book and get a general overview of what will be involved in composing one painting. The recommended size is 8" x 10", on the small size but you'll still be able to get plenty of detail in your subjects if you don't make them too small.

There are several parameters I'd like you to follow:
1. have a background, middle ground, and foreground, even if the background is only a couple of inches of sky. That counts
2. have at least five elements in your painting -- they don't all have to be major elements
3. use a full range of values

Choose a subject that inspires you. Get out your sketchbook and do some doodling. Make lists. Make some thumbnails. And then sit back and give your ideas some time to take shape. Go on and do something else for a while.

Take this time to practice clouds and textures as described in the section of this workbook on painting. If you have a real rock, piece of bark or wood or a beautiful sky outside your window as models -- great! But this is practice and copying photos is fine.

Session 2

Research - When you've chosen your subject and different elements you want to include in your painting do some research. If you've chosen a young animal and some botanical subjects, make sure those blooming flowers are in the same time frame as the age of your animal. You don't want to put a new born spotted fawn in a painting with golden rod and bursting milk weed pods. If you've chosen a pair of birds, research the differences between the male and female. If you have very different subjects in your painting you may have to research their sizes. Use online resources, the library, your photo files or something from your "morgue" (a collection of clippings from magazines and news-papers).

Composition & Layout - You may want to make several larger thumbnails that are a bit more detailed. Place your horizon line and major elements. Play with them. Switch them around and see what looks best to you -- what composition is best to showcase your subjects. Once they choose a good composition, some artists do a very detailed drawing and they include values. Because I'm still changing my mind, even as I'm drawing on my final paper, that doesn't work for me. I keep my thumbnails rough.

Drawing - When you begin your drawing on your good paper, it's time to start making final decisions. Instead of making a good drawing of one of your elements directly on your paper and then finding that it's too large or too small, try drawing it on another piece of paper or tracing paper. Don't make a detailed drawing -- you're just going to paint over it. Using a copy machine, make copies in several different sizes and cut them out. Tape them in place on your good paper to see what size or position is best. When I've found what I think will work, I cover the back of the copy with soft graphite and transfer the drawing to my good paper by tracing over the lines. Your lines may be light so you may want to either darken them with graphite or paint over them with a very narrow stroke so they don't get lost when you begin painting. Graphite might smear so I recommend the very thin line of paint.

Sessions 3 & 4

Painting -- The recommendations in this section are for those who have chosen to work with gouache. Painting with gouache, because of all the layering, blending and fine detail work, is a very slow process.

Start painting the most distant elements first and work forward. If you have distant trees against your sky you may not even want to draw the trees in. Paint in the sky and paint your trees over it. You should have your original sketch to see where they should be placed. Remember that distant objects are bluer and less distinct with little detail.

As you work forward, the colors should become more intense and you should include more detail. Paint light over dark. Your layers of paint will mix together and make beautiful variations instead of a plain, flat color that won't look natural. Be sure to soften the edges of your elements so they won't look like they've been pasted on your paper. The general process is to paint a thin dark layer of underpainting and build lighter, thicker layers over it. Blend your strokes a little to take the hard edge off and also soften the outside edges of your elements.

Also, remember that it's not good for the human body to sit in one position for too long. Take frequent breaks to stretch and then you can come back to your painting with fresh eyes.

Four hours is not long enough to complete your painting so my students are instructed to finish it out of class.

Session 5

Framing -- The easiest, but most expensive, solution is to have your painting professionally framed. That's not an option for everyone, especially if you have several paintings ready for finishing.

Inexpensive but quite suitable frames can be found at national chain stores for reasonable prices. Try to buy wood instead of the low grade plastic material. There's no way to attach screw eyes or strap hangers to the plastic type and many galleries won't accept saw tooth hangers. If the painting is to be hung in your home that is your decision. Another good place to find frames is a Goodwill store. Sometimes chain stores and Goodwill will have glass that comes with the frame. Sometimes not.

Precut mats in standard sizes can be found at Michael's, Hobby Lobby and at many online suppliers. However, if you'll continue to need mats it's not that difficult to learn how to do it yourself. Youll need a specialty mat cutter that can cut beveled edges. Check out an online tutorial or an instruction book at the library. When you choose your mat pick a color that complements your painting and won't overpower it.

Line up your artwork on the backboard so that it shows correctly through your mat window. Place your mat over it to check. Then attach your artwork to the backboard with Japanese paper and rice paste hinges (traditional method) or with acid free white artist's tape (my way).

Sandwich the frame, glass, mat, artwork and backboard together. I use the frame tool that shoots glazier's points into the back edges of the wooden fame to hold everything securely together. Then cut a brown paper dust cover, run a bead of glue along the back edge of the frame and press the dust cover down. Let dry. Then you're ready to install the hardware. Put your screw eyes or hangers about 1/3 of the way down from the top of the painting. Add the wire and you're done!

Books & Sites to Check Out

How to pick the best reference books for natural science illustrators . . . Impossible! The list would go on and on and I would recommend different ones for different artists. All I can do is pass on the names of books and sites that have inspired, educated and enlightened me.

The Guild Handbook of Natural Science Illustration, Elain Hodges, 2003 -- A comprehensive guide to all facets of natural science illustration. Also visit their web site, www.gnsi.org, and consider joining the group. There's a yearly fee but it's well worth it. To check out the work of the many talented guild artists go to www.science-art.com

Creating Nature in Watercolor, an Artist's Guide, Cathy Johnson, 2007, Actually, any of Cathy Johnson's over 40 books is a gem. Her knowledge, skill and enthusiasm for her subjects comes through her writing. She is an inspiration. Visit her web site at: http://cathyjohnson.info/

Botanicals

Beautiful Botanicals - Bente Starcke King, 2004, various media, book is spiral bound so it will lay flat

Botany for the Artist, Sarah Simblet,2010, drawings, photos and paintings of all types of botanical specimens

Botanical Illustration Course with the Eden Project, Rosie Martin & Meriel Thurstan, 2006, drawings & watercolor paintings

Wildflowers of the Great Lakes Region, Roberta L. Simonds & Henrietta H. Tweedie, 1978, black and white line drawings

Animal Art

Anatomy of Animals, Ernest Thompson Seton, 1977, black and white renderings

The Laws Guide to Drawing Birds, John Muir Laws 2012, in depth guide to drawing with a section on colored pencil and watercolor painting

Animal Art -- continued

Natural History Painting with the Eden Project, Rosie Martin & Meriel Thurstan, 2009, drawing and watercolor painting

Wildlife -- the Nature Paintings of Carl Brenders, 1994, master of detail

The Art of Robert Bateman, Ramsay Derry, 1981

Horses, Rien Poortvliet, 1976, drawings and paintings

Animals in Motion, Edweard Muybridge, Dover, 1957, landmark photos of animals in motion

Bird Reference Drawings, David Morhardt, 1985, black and white line drawings, spiral bound

Bird Studies, David Morhadt, 1986, black and white studies with measurements, spiral bound

Michigan Turtles and Lizards, James Harding & J. Alan Holman, 1990, photographs

Art Suppliers

Your local Michael's or United Art & Education stores carry many of the artist's supplies most commonly used. The following online stores generally carry a much wider variety of tools and materials:

dickblick.com
misterart.com
cheapjoes.com
jerrysArtarama.com

Wrap Up

If there's anything you take away from this experience, I hope that it's to follow your passion and paint what interests you and holds your attention. Your attitude toward your subject can show through and be a window to the rest of the world into how and what you see around you -- all those beautiful and colorful flowers, birds and butterflies; the shy forest animals; the slithering or slimy things.

And don't forget to practice, practice, practice! Practice your drawing and painting skills. Practice your observational skills. Natural science illustration can be a rewarding and lifelong path.

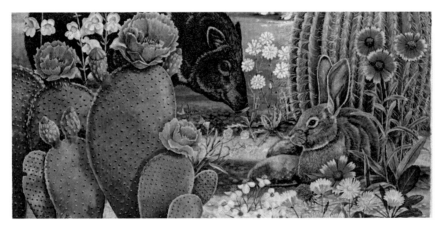

Check out the Learning Center on my web site:
www.soundofwings.com
for more instructional workbooks
on painting with gouache.

Botanical Illustration in Gouache
Botanical Illustration in Gouache - the Four Seasons
Painting Birds in Gouache
Painting Animals in Gouache
Painting Butterflies & Moths in Gouache
Painting Toads & Turtles in Gouache

And if you have any questions or comments I'd love to hear from you:
e mail me at sandy@soundofwings.com

Made in United States
North Haven, CT
18 February 2023

32796459R00029